Ashleigh Wilson is the arts editor of *The Australian*. He won a Walkley Award in 2006 for his series on unethical behaviour in the Aboriginal art industry, which led to a Senate inquiry. His book *Brett Whiteley: Art, Life and the Other Thing* was published by Text Publishing in 2016.

Writers in the *On Series*

Ashleigh Wilson

On Artists

hachette
AUSTRALIA

FOR ZOE AND RAPHAEL

Every attempt has been made to locate the copyright holders for material quoted in this book. Any person or organisation that may have been overlooked or misattributed may contact the publisher.

Published in Australia and New Zealand in 2020
by Hachette Australia
(an imprint of Hachette Australia Pty Limited)
Level 17, 207 Kent Street, Sydney NSW 2000
www.hachette.com.au

First published in 2019 by Melbourne University Publishing

10 9 8 7 6 5 4 3 2 1

A catalogue record for this book is available from the National Library of Australia

ISBN: 978 0 7336 4440 5 (paperback)

Original cover concept by Nada Backovic Design
Text design by Alice Graphics
Typeset by Typeskill
Printed and bound in Australia by McPherson's Printing Group

The paper this book is printed on is certified against the Forest Stewardship Council® Standards. McPherson's Printing Group holds FSC® chain of custody certification SA-COC-005379. FSC® promotes environmentally responsible, socially beneficial and economically viable management of the world's forests.

1

It has invariably happened that the works which they have made have been, in some degree, the proofs of the character of the workmen; for who is there who, when he looks upon statues or pictures, does not at once form an idea of the statuary or painter himself? And who, when he beholds a garment, or a ship, or a house, does not in a moment conceive a notion of the weaver, or shipbuilder, or architect, who has made them?

—Philo Judaeus, the Alexandrian philosopher, roughly two thousand years ago

Let's begin with the filmmaker whose obsession with his female lead ended her career. They were worlds apart: he was a formidable figure, already one of the greats, while this was her first film. He had noticed her in a television advertisement. Now he was making her a star.

On their first movie together, his fixation was obvious to the crew. He stared at her constantly. He showered her with gifts. He had her followed when she was away from the set. He told her what to wear and who to see socially. On their second movie he built her a trailer with a private entrance to his office, which is why she learned to invite friends over to avoid encountering him alone. When he finally made a sexual advance that she couldn't ignore, she turned him down. His retaliation

was immediate: he froze her out during the remainder of filming and then killed her career.

Half a century before Harvey Weinstein changed everything, Alfred Hitchcock was in California, making life hell for Tippi Hedren. Their first film together was *The Birds*; the second was *Marnie*. While shooting *The Birds* in 1962, Hitchcock subjected Hedren to a sustained period of emotional and physical torture during the climactic scene, when her character comes under attack in a room full of seagulls, crows and ravens. Those were real birds, and Hedren collapsed after several days of filming. She later described this as the worst week of her life.

The next film, *Marnie* (1964), had a strange plot. Businessman Mark Rutland (Sean Connery) becomes besotted with a thief,

Marnie Edgar, after she steals from his company. He convinces her to marry him, rapes her on their honeymoon and then discovers the childhood trauma that made her fear intimacy. Hitchcock had originally wanted Grace Kelly to play Marnie, but when he settled on Hedren his obsession went up another notch. He even asked the make-up department to create a life mask of her face for his own use. You don't need to know what happened behind the scenes to find some of the dialogue unsettling:

> Marnie: Just let me go, Mark, please. Mark, you don't know me. Oh, listen to me, Mark, I am not like other people. I know what I am.
>
> Mark: I doubt that you do. In any event we'll just have to deal with whatever it

is that you are. Whatever you are, I love you. It's horrible, I know, but I do love you.

Marnie: You don't love me. I'm just something you caught. You think I'm some kind of animal you trapped.

Mark: That's right, you are. And I've caught something really wild this time, haven't I? I trapped you and caught you and by God I'm going to keep you.

It was during the filming of *Marnie* that Hitchcock tried to become intimate with Hedren. After she refused, he started calling her 'the girl' around the set and lost interest in the film. He then refused to release her from her contract and told other filmmakers she was unavailable for future roles.

He was a sexual predator, but he was also Alfred Hitchcock, and he had the power to ruin careers.

But that was then.

<p style="text-align:center">***</p>

In late 2017 the fall of Harvey Weinstein prompted profound conversations about power and misogyny in the modern world. Weinstein, one of the most influential producers in Hollywood, was accused of sexually assaulting dozens of women over his long career. His behaviour had been an open secret, but that silence was over. A new movement was born, one that came to be known by a hashtag of inclusion, amplifying a cause that had first been named a decade earlier: #MeToo.

After Weinstein other public figures have also fallen from grace, and more will follow. But already there is one development pushing back against hundreds of years of tradition: the excuse of the creative genius. No longer is the artist allowed to live apart from the rest of society. No longer can the artist be excused from the standards of conduct that apply to us all. This excuse has been circulating for centuries: to be creative was to be prone to eccentricity, melancholy, madness, addiction, neurosis, reclusiveness, egotism, penury—or any number of flaws said to contribute to the cost of making art. Great art may well demand a certain character from its maker, but the tolerance of the past has been cast aside.

We don't have to search far through history to find artists behaving badly. Caravaggio was

a belligerent brawler who fled Rome after killing a man. Cellini took countless lives. Lord Byron, 'mad, bad and dangerous to know', had an affair with his half-sister. André Gide was a self-described pederast. Picasso abused women. William Burroughs killed his wife in a drunken game of William Tell. James Brown was arrested on domestic violence charges. Roman Polanski pleaded guilty to sex with a minor. Mel Gibson made anti-Semitic comments to a police officer. The list goes on.

But that was then. The world is now a lot less willing to forgive transgressions from lives devoted to creativity. After a few hundred years of excuses, this is well overdue.

What does this mean for the art? It's one thing to call misbehaving artists to account, but it's quite another to banish their work at

the same time. The impulse to boycott artists has much to do with taking a stand, to demonstrate, commercially or otherwise, that such behaviour will not be tolerated. This is especially the case when the artist is still alive to profit from their work, and even more so if they are seen to have escaped legal consequences or failed to appropriately atone.

There's not much point trying to separate the artist from their art, since the two have long been inseparable. But as the spotlight falls on more artists, both living and long dead, we find ourselves at an uneasy juncture: if we denounce the artist, then what do we do with the work? Once we start removing paintings from walls, where do we stop?

'A thing of beauty is a joy forever', wrote Keats in 1818, and surely he had a point.

To value a piece of work does not require us to applaud its creator. Great art will endure regardless of whether we approve of the hand that made it. Or will it? Have we reached a point of absolute conviction where a thing of beauty is no longer enough?

There are no easy answers to these questions. The debate is packed with contradictions and inconsistencies that are difficult to resolve. It also has a way of focusing attention on the misbehaving artists instead of their victims, as Australian writer Clementine Ford pointed out in *The Guardian* in 2018: 'You want to talk about ruined careers? Look at what happens to the women who dare to speak out against or refuse the advances of powerful men … And what of the women whose work we'll never see at all, because abuse, trauma and exploitation

derailed their carts before they even made it on the tracks?'

Ford argued that the world would be fine without Picasso or Woody Allen. Perhaps so, but if we accept that some artists have been acting like this for many years—'Caravaggio's preoccupation with his painting', wrote Giovanni Pietro Bellori in 1672, 'did not calm the restlessness of his spirit'—then the question remains: how do we deal with the work they have left behind?

When it comes to art, I would like to think we're big enough to factor in the messy turbulence of humanity, to understand that artists act with the same range of behaviour as the rest of us. But then I think of the wreckage of lives whose names we barely know, and the painter who liked young boys, and the composer who

hated Jews, and the choreographer who abused his dancers, and the conductor who took advantage of his musicians, and the singer who installed a hidden camera in the ladies bathroom of his restaurant. (That last one, by the way, was Chuck Berry.)

No longer can we ignore the circumstances that gave rise to the art, so maybe a level of discomfort comes with the territory. The American singer CeeLo Green seemed uneasy in 2014 when he expressed admiration for the 1970s glam rocker Gary Glitter. Green said he was aware of Glitter's child pornography offences, but still appreciated his music.

In 2018 journalist Rosemary Neill broke a most uncomfortable story in *The Weekend Australian* about the late Australian poet

Dorothy Hewett. Sixteen years after Hewett's death, her two daughters revealed that their mother had allowed older men to prey on them as teenagers. The 1970s suddenly felt like another world.

Once we know what happened in the Hewett house, does anything change when we encounter lines like this?

> In this romantic house each storey's peeled
> for rapists randy poets & their lovers
> young men in jeans play out seductive ballets
> partner my naked girls
> scripts by Polanski Russell Nabokov

Once we know about Louis CK, and the way the comedian masturbated in front of women, do we still laugh when he makes edgy jokes about sex?

Once we know about Kevin Spacey, and the behaviour that cast him out of an industry he once dominated, do we still admire the contrivances of his character Frank Underwood in *House of Cards*?

Once we know about Bill Cosby, and the predatory sex crimes that sent him to jail, do we still chuckle along with Cliff Huxtable?

Once we know about Bernardo Bertolucci, and the way he surprised Maria Schneider while filming a rape scene because he 'wanted her reaction as a girl, not as an actress', how do we watch *Last Tango in Paris*?

Once we read the accusations against Woody Allen, how do we watch that scene in *Annie Hall* when he sits in a childhood classroom as an adult, talking about healthy sexual curiosity?

Once we read Eryn Jean Norvill's account about working with Geoffrey Rush, do we adjust our opinion of his performance as King Lear?

And once we know about Alfred Hitchcock, how can we watch *The Birds* or *Marnie* without considering the suffering of Tippi Hedren?

Her story is no secret: I drew my account from Donald Spoto's 1983 biography, which in 2012 was turned into a film, *The Girl*. And yet Hitchcock remains one of the greats. Hedren's story needs to be heard. But does her experience change the merit of Hitchcock's films? Can we judge artistic merit in a vacuum anyway?

As it happens, Hedren found a way to live with the gap between the man and his art. In 2012, to mark the release of *The Girl*, she told

the *Huffington Post* that Hitchcock was 'evil' as a person but talented as a director: 'What he gave to the motion picture industry can never be take away from him and I certainly wouldn't be one to try'. And to *The New York Times*, she said: 'He ruined my career, but he didn't ruin my life. That time of my life was over. I still admire the man for who he was'.

This is worth repeating: despite the abuse, she still admired his work.

For the best part of twenty-five years I've had one album on regular rotation. *Kind of Blue*, the 1959 masterpiece by Miles Davis, always sounds fresh and poignant, as close to perfect as a piece of music could be. The third track is a ballad called 'Blue in Green', and it gives me

goosebumps every time. The whole band is in sync but to hear Davis searching through the melody, gently, wistfully, making his way up to that B flat near the end—I can't explain the sensation, but somehow it works for me as a soundtrack to all sorts of high emotions, from elation and relief to darkness and despair.

Over the years, like any fan, I found myself reading about the life of the man who made this music. As a trumpeter and band leader, Davis was one of the most influential musicians of the twentieth century. As a man, well, where to start? Davis led a rich life, he pushed back against racial discrimination, and he was impossibly cool, which is probably why there's a poster of him on my office wall—but he could also be deeply unpleasant, especially to women.

The raw beauty of his music needs to be balanced with lines like this from his 1989 autobiography: 'I remember I hit her once when she came home and told me some shit about Quincy Jones being handsome'. Or this about a different woman: 'One time we argued about one friend in particular, and I just slapped the shit out of her … Before I knew it, I had slapped her again'.

None of this is news to anyone who knows a little about jazz. Miles Davis is well known as both a creative genius and a fiery individual who beat women. What to do with this knowledge, though, is less clear. To admire his music is not to excuse his behaviour. But of course I would say that: I love his music, so I'm reluctant to find a reason to cut his work from my life.

I feel the same about Michael Jackson, having grown up with his music. If he had been sent to prison, would that have changed? The nature of the offending matters, and sex crimes, especially against children, are hard to ignore. Jackson was facing court on four charges of child molestation, among other charges, so it was a possibility that the jury could have found him guilty in 2005. And while a conviction would have had nothing to do with the music he recorded years earlier, listening to 'Billie Jean' or 'Thriller' would have been a more complicated experience, even if the appeal of those songs hadn't changed one bit.

The nature of the offending matters, especially when it comes to alcohol and drugs. Australians have been prepared forgive—even to celebrate—artists who commit crimes

in a state of intoxication. In 2015, a year after his release from prison for armed robbery, Nigel Milsom won the Archibald Prize with a painting of his lawyer, Charles Waterstreet. The late Adam Cullen, who won the same award fifteen years earlier, faced court in 2011 on drink driving and firearms offences, and received a glowing character reference from the Art Gallery of New South Wales' then director, Edmund Capon.

But the times are changing, as Rozalind Dineen pointed out recently in *The Times Literary Supplement*: 'The artist-addict bromide is not what it once was. It's easier to imagine a successful young artist in 2018 with a publicist than a habit'.

The nature of the offending matters, but so too does the quality of the art. To illustrate

both, let's take the case of Rolf Harris. Forty-one years after he performed at the opening of the Sydney Opera House, Harris was sentenced in London to more than five years in jail for sexually assaulting girls and young women. Those are not the sort of crimes that anyone is in a hurry to forgive. And maybe it's just me, but it's hard to imagine many people arguing to separate the art from the artist when the case for the former is 'Tie Me Kangaroo Down, Sport'.

Harris is now known as much for his crimes as his work. Maybe his career was always dependent on celebrity, making it inevitable that his work would fall away with his reputation. But when he faced court in 2014, three years before the Weinstein scandal broke, the ground was already shifting. And when

he was sent to jail his paintings and books began to disappear in Australia without any public lamentation.

Those poor artists. We can go as far back as Aristotle to hear talk about the link between art, genius and melancholy. Fast forward to 1587 and Giovanni Battista Armenini, an Italian critic and historian, was already fed up: 'An awful habit has developed among common folk and even among the educated, to whom it seems natural that a painter of the highest distinction must show signs of some ugly and nefarious vice allied with a capricious and eccentric temperament, springing from his abstruse mind. And the worst is that many ignorant artists believe themselves to

be very exceptional by affecting melancholy and eccentricity'.

I came across Armenini's thoughts in a fascinating book, first published in 1963, called *Born Under Saturn*. The book was written by Margot and Rudolf Wittkower, and the title is a reference to the influence of Saturn on melancholy—one of the four temperaments, or humours, that ancient physicians felt needed to be in balance for a healthy body and mind.

The Wittkowers investigate the evolution of the idea that artistic inspiration equals madness, to allow artists to stand apart from society. They explain what happened during the Renaissance, when artists turned away from the protective bond of medieval guilds to pursue a new kind of individualism. Then,

300 years later, Romantic artists fought to be liberated from the professional academies that had flourished since the seventeenth century.

'The image of the Bohemian took shape,' they write, 'fostered as much by the ideology and conduct of the artists as by the reaction of the society on the fringe of which they lived'.

Context matters. Our thoughts and actions are profoundly shaped by our social environments, as the British philosopher Julian Baggini argued in a recent piece for the online publication *Aeon*. Caravaggio is unlikely to have had the freedom to paint those haunting masterpieces if he had killed a man in 2006 instead of 1606. Miles Davis would have had questions to answer if his wife stepped outside

her Manhattan apartment today with a black eye. And it's hard to imagine collectors overlooking Picasso's relationships with women if he was documenting it all on Instagram along with pithy lines like this: 'Women are machines for suffering'.

The work of Picasso is partly what makes a visit to New York's Museum of Modern Art (MoMA) such a rewarding experience. On level five, if you make your way past the tourists taking selfies with Van Gogh's *The Starry Night*, another iconic image beckons from an adjacent space: *Les Demoiselles d'Avignon*, a picture that still feels so physical and confronting more than a century after Picasso painted it.

According to Glenn Lowry, the director of MoMA, we understand Caravaggio differently

when we take into account the details of his life. The same goes for Picasso, whose relationship with women was a 'central dimension' of his art. 'It's not hidden,' Lowry says. 'But perhaps we look at that today and ask different questions of the art and different questions of what kind of permission he had, and what was the impact of those acts on the women with whom he was involved … There's now a different urgency to how that information is shared.'

In April 2018 I travelled to New York to write a newspaper profile on Lowry, who's been in the job since 1995. As well as participating in the profile, he was happy to discuss the matter of disreputable artists. 'Of course biography matters', he said. 'How we weight it is a different story.'

Artists, said Lowry, are humans like the rest of us. But he told me that we're living in a 'very fraught moment where everything is really raw', so the kind of behaviour that might have been acceptable in the past was now 'absolutely unacceptable'.

He went on: 'Now we've reacted to that and, God-willing, the norms will have been reset and that behaviour will gradually disappear. Although I'm not as convinced of that as one might be, but certainly its acceptance will no longer be possible'.

In conversation, Lowry takes his time, asks questions of himself and doesn't rush to judgement. 'You look backwards,' he said, 'and the art remains. Does it matter? Of course it matters. It changes our understanding. Does it

mean you take the art off view? I don't think so. I think time tempers this. In other words, it's one thing when an artist is alive and he or she has done something heinous, and it's in real time. It's another thing when 300 years have passed or 500 years have passed and you can situate an act within the larger context of a body of work'.

As I left his office, Lowry mentioned that he was currently reading *The Collector of Lives*, a new biography of the Italian art historian Giorgio Vasari. Born in 1511, Vasari is best known for writing a series of artist biographies called *The Lives of the Most Excellent Painters, Sculptors and Architects*. Quite the coincidence, then, since Vasari was one of the first to encourage us to look closer into

the lives of artists, a curiosity that spawned an industry that thrives to this day.

From Vasari onwards we have been encouraged to inspect the hand holding the brush, to ask questions about the lives of artists, to consider their triumphs and failures, to piece together the circumstances that led them from one event to the next—and in doing so, to look for connections, however implicit, between the life and the work. It's no accident that Vasari was working in the Renaissance, when artists were embracing individual identities with particular abandon.

I'm part of this tradition myself. A few years ago I wrote a biography of Brett Whiteley,

who died in 1992. Published in 2016, it was called *Art, Life and the Other Thing*, a title that took its name from a self-portrait which earned Whiteley the 1978 Archibald Prize. The details of his life make a great story—drugs, sex, famous friends, a talent recognised from a young age—but his reputation endures because of his talent rather than any of the fireworks he set off during his life.

Midway through the book, I give some context to pictures Whiteley created from late 1973, based on the view from his home in Lavender Bay. These paintings reveal the artist at the height of his powers, and have become eagerly sought after by collectors. Whiteley had been in a reflective mood when he made these works, following several

years of socially charged art. He was turning inward, inspired by the Japanese printmaker Hokusai: 'I am interested in beauty, which can best be described as being on time for an appointment'. Does it matter that he had also started using heroin around this time? I gave the details but left it up to others to decide.

Whiteley blurred the line between art and life anyway. Consider the painting that gave my book its title. On the right is a photo of the artist; in the middle, a distorted figure of him engaging with Australian art history; and on the left, a screaming baboon with nails in its paws and a syringe. You don't need my help to know that he was making a statement about addiction, scrubbing away the lines that separated art and life.

On 16 October 1590 a young composer from a prominent Italian family stormed into an apartment in Naples to confront his wife and her lover. His name was Carlo Gesualdo, the prince of Venosa, and the cousin he had married four years earlier was having an affair with a handsome young duke. Witnesses heard the commotion before they saw the horror. Gesualdo had killed both of them, mutilated their bodies, then fled the scene. He went on to write a series of radical compositions for small groups of singers that continue to enchant listeners to this day.

Music critic Alex Ross probed the Gesualdo myth in a piece for *The New Yorker* in 2011. He made the point that Gesualdo's music might not have received such close attention if he hadn't committed such shocking acts. But

if he had not written such shocking music, then his life would probably not have held such fascination to begin with.

Ross also raised the case of another Renaissance artist known for darkness in his work and his life. 'Many bloodier crimes have been forgotten; it's the nexus of high art and foul play that catches our fancy,' he wrote. 'As with Gesualdo's contemporary Caravaggio, who killed a man by stabbing him near the groin, we wonder whether the violence of the art and the violence of the man emanated from the same demoniac source.'

At a basic level it's impossible to detach the artist from the art. As long as humans are making art, then the context of their lives influences the work they produce. But how can we measure the extent of that influence?

How much weight should we give to the life when decoding the mysteries of the art? Sometimes, as with Gesualdo and Caravaggio, it's tempting to look for meaning in the life, especially when the answers we find seem so revealing of the work.

In a modern context, actors like Kevin Spacey invite a similar kind of introspection. In late 2017, only a few weeks after we learned about Weinstein, Spacey's reputation collapsed when he was accused of making an unwelcome sexual advance on a younger actor, Anthony Rapp, when Rapp was a teenager. Spacey wrote a public apology to Rapp, but lost any public sympathy that might have remained when he combined the apology with an announcement that he chose to 'live as a gay man', an entirely irrelevant detail,

before others came forward with separate accusations as well.

Once we've listened to Rapp, and subsequent accusations from others, it's interesting to look back on some of Spacey's most memorable roles: the elusive criminal Verbal Kent in *The Usual Suspects*, a role that earned him an Oscar for best supporting actor; the serial killer John Doe in *Seven*; Lester Burnham, a businessman suffering a midlife crisis in *American Beauty*, which earned him another Oscar as best actor; and, on television, the ruthless politician Francis Underwood in *House of Cards*. I also thought he was excellent in the title role of *Richard III* when the production came to Sydney in 2011.

Each of these characters appear deceitful, selfish, ravenous and manipulative. You can

find similar qualities in his other films, too, like *Superman Returns*, *21*, *Horrible Bosses* and *Baby Driver*. And so, looking back, that sense of discomfort returns.

On the surface, nothing has changed. Strong performances don't suddenly lose their power because they edge close to the man behind the mask. But they make you wonder. Was the fuel that powered his private life the same as the fuel that powered his performances? Spacey is an actor, so he's playing a part. But each of those parts still spring from within the same man.

Spacey himself tapped into this ambiguity when he posted a three-minute video on Christmas Eve, shortly after news broke that he was being charged with sexually assaulting an 18-year-old at a Nantucket bar in 2016.

The video was called 'Let Me Be Frank', and it showed Spacey in a Santa apron, speaking directly to the viewer with a Francis Underwood drawl: 'You wouldn't believe the worst without evidence, would you? You wouldn't rush to judgement without facts, would you?'

Within a month this video had been watched on YouTube more than ten million times.

George Orwell was also wrestling with questions of character when he took on Salvador Dalí. It was 1944 and Dalí had recently published an autobiography that opened like this: 'At the age of six I wanted to be a cook. At seven I wanted to be Napoleon. And my ambition has been growing steadily ever since'.

Orwell was repulsed by Dalí's cruelty and narcissism. He said he was as 'anti-social as a flea', and called his work 'diseased and disgusting'. He wondered what it revealed about a society that allowed these aberrations and perversions to flourish.

'If Shakespeare returned to the earth tomorrow,' Orwell wrote, 'and if it were found that his favourite recreation was raping little girls in railway carriages, we should not tell him to go ahead with it on the ground that he might write another *King Lear*'.

Despite this, he would not deny Dalí's talent: 'The two qualities that Dalí unquestionably possesses are a gift for drawing and an atrocious egoism'. If it were possible for a book to give a 'physical stink off its pages',

then Dalí's autobiography would qualify. The fact he was also a 'draughtsman of very exceptional gifts' was another matter. 'He is an exhibitionist and a careerist, but he is not a fraud. He has fifty times more talent than most of the people who would denounce his morals and jeer at his paintings.'

Orwell thought there was something rotten at the heart of Dalí's character. He argued that encouraging 'necrophilic reveries' caused as much harm as picking pockets at the races. 'One ought to be able to hold in one's head simultaneously the two facts that Dalí is a good draughtsman and a disgusting human being. The one does not invalidate or, in a sense, affect the other.'

In his 2001 Nobel lecture VS Naipaul spoke with great insight about his background, a story that stretched from India to Trinidad and Britain, and how all of it came to inform his work. 'I am the sum of my books', he said.

Naipaul also reflected on the identity of writers. He leaned on Marcel Proust, who once wrote a series of essays taking issue with a French critic who said it was important to know the details of a writer's life to understand a writer. Proust had a different view: the book was the 'product of a different self from the self we manifest in our habits, in our social life, in our vices'. Naipaul said these words should be with us whenever we read a biography of a writer or 'anyone who depends on what can be called inspiration'.

'All the details of the life and the quirks and the friendships can be laid out for us, but the mystery of the writing will remain. No amount of documentation, however fascinating, can take us there. The biography of a writer—or even the autobiography—will always have this incompleteness.'

Seven years later the literary world was treated to a revealing biography of Naipaul himself. Naipaul had co-operated with the writer Patrick French, but that didn't stop plenty of unflattering material from appearing in the book. Naipaul was shown to be a brilliant writer, but also cruel and egotistical, a 'great prostitute man' who tormented his first wife and put many others off-side.

When Naipaul died in 2018, aged eighty-five, obituary writers emphasised the strengths

of his talent as well as the flaws of his character. But as with Whiteley, or any artist who leads a life of extremes, the emphasis was always on the talent. Those obituaries were being written because Naipaul was one of the greats of English literature; the details of his life, however obnoxious or offensive, could never take away from that point. If readers continue to admire Naipaul's writing, as I'm sure they will, then his insistence on the limitations of biography will have prevailed.

But just as the details of the life can never erase the work, the quality of work can never excuse the life. As Linton Kwesi Johnson, the Jamaican-born poet, once said about Naipaul: 'He's a living example of how art transcends the artist 'cos he talks a load of shit but still writes excellent books.'

2

Let's return to Kevin Spacey, and the strange case of John Paul Getty. In November 2017, after the news broke about Spacey's behaviour, Netflix cut the actor from *House of Cards* and abandoned a biopic on the late Gore Vidal, which starred Spacey in the title role.

At the same time director Ridley Scott faced a unique challenge. His new film, *All the Money in the World*, was scheduled to open the following month. Based on a true story, the film was about the kidnapping of Getty's grandson and the billionaire's reluctance to pay a ransom. But the trailer, already released, revealed the problem: it built up to

a crescendo that revealed Spacey, in heavy make-up, as Getty.

Scott flew to Manhattan to ask Christopher Plummer to take over as Getty. Plummer had initially been considered for the role, and was closer in age to the character than Spacey. The movie was all but finished; however, Scott wanted to reshoot the scenes that had Spacey in them, replacing him with Plummer. Plummer agreed and the rest of the cast and crew returned to the set. (There was some controversy later when it was revealed that Mark Wahlberg had negotiated a substantially bigger fee to return than his co-star Michelle Williams; Wahlberg later donated his payment to the sexual assault initiative Time's Up.)

All the Money in the World, with Plummer as Getty, opened in Australia in January 2018,

a few weeks after its premiere in the United States. Plummer was nominated for an Academy Award as best supporting actor. The nomination was well deserved: he's very effective as Getty, offering brief glimpses of warmth within an otherwise severe demeanour. If it wasn't for all the publicity surrounding the original casting, no one would suspect what had gone on behind the scenes.

How does Plummer compare to Spacey? We can only judge from the trailer, where Spacey comes across as colder, more calculating and harsh. We can't know for sure, though, without seeing both films, and that's not likely to happen any time soon.

But the director saw both performances up close. When he made the decision to replace Spacey, he was thinking about all the people

involved in the making of the film and all the money invested in its success, and the toxic atmosphere that now threatened to accompany its release.

Scott explained that cutting Spacey had been a business decision, not an artistic one. He told *The Guardian* that Spacey was a 'very good actor' who had delivered a flawless performance: 'When I finished it with Kevin, it was kind of perfect.'

But still he had to go.

During one interview, Michelle Williams argued that removing Spacey did nothing to ease the 'pain and suffering' of people affected by his behaviour, but said it was important to have done something. 'It's just a little stand on our part, saying this behaviour shouldn't

be tolerated, it shouldn't be accepted and if it can be, you know, erased, it should be.'

Is this solution—erasure, deletion, the expunging of the art to reject the artist—the best way to deal with bad behaviour?

In 2014 Opera Australia parted company with Georgian soprano Tamar Iveri over homophobic comments on her Facebook page. Four years later TV executives in the United States cancelled the *Roseanne* sitcom after its star and co-creator, Roseanne Barr, tweeted a racist comment about Valerie Jarrett, a former advisor to Barack Obama. Around the same time, a Sydney gallery was quietly removing an Australian artist from

a group exhibition after he was accused of domestic violence.

In Australia there have also been periodic rumblings about the late Donald Friend, an artist and writer who openly discussed his relationship with young boys in Bali and elsewhere. In 2016 the Tweed Regional Gallery removed a portrait of the artist and pulled his diary from its bookshop. The following year the Tamworth Regional Art Gallery removed twelve of his pictures from display, according to *The Northern Daily Leader*, 'after becoming aware of the controversial nature of the artist'. Friend's private life has long been an open secret: in his introduction to the artist's collection of diaries, for example, Barry Humphries referred to Friend's 'benevolent' pedophilia. It's possible there hasn't been

a greater fuss about the artist because he remains relatively minor compared to some of his peers: if he had the reputation of Arthur Boyd or Fred Williams, for example, then these questions would be a lot louder and more urgent.

A more high-profile case took place in Washington in January 2018, when the National Gallery of Art cancelled a forth-coming Chuck Close exhibition after reports that the artist had sexually harassed several women who had posed for him. Close had apologised for making anyone embarrassed or uncomfortable and admitted to having a dirty mouth, but the decision was made.

The gallery also cancelled a show by Thomas Roma, a photographer accused of sexual misconduct. But its decision about

Close, a prominent American artist, drew the most attention, given his standing in the art world. While it continued to hold Close's work in its permanent collection, the gallery said it would not be appropriate to present an exhibition.

Close's art may well stand the test of time, but while he's alive gallery directors will think twice about staging exhibitions of his work. One alternative is to acknowledge unsavoury character while celebrating an artist's work. This is what happened in 2017, when an Eric Gill exhibition opened at the Ditchling Museum of Art and Craft in Sussex. Gill, who died in 1940, was a sculptor who sexually abused his daughters. The show's publicity material was open about his flaws, asking whether 'knowledge of Gill's

disturbing biography' affects our appreciation of his work.

Rachel Campbell-Johnston, the chief art critic for *The Times*, described the result as both repulsive and mesmerising. 'It is the perversions of Gill's biography—not his artistic creations—that are abhorrent. Art should not be demonised. Rather, it remains the duty of a civilised society to preserve artworks that reveal our human nature—even with its worst flaws.'

There are many factors that go into deciding which artists deserve prominence and what work should be acquired for permanent collections. When a director considers the purchase of a work, they might be making a

judgement about creative achievement while weighing up the need to fill gaps in their collection, perhaps by style, gender or era, as well as considering issues to do with price and provenance. If that artist is seen as 'problematic'—a euphemism used to cover any number of failings—then the director might conclude that it's wiser, aesthetically or morally or commercially, to look for a different option. A similar process takes place when deciding which works to hang on the walls.

Elizabeth Ann Macgregor, director of the Museum of Contemporary Art (MCA) in Sydney, takes a practical approach. Macgregor is also president of the International Committee for Museums and Collections of Modern Art, part of the International Council of

Museums, so she's aware of the sensitivities involved.

'We have so many artists to choose from,' she told me, 'that we should avoid those that have been shown to have a pattern of inappropriate behaviour. Same applies to curators (and critics!). Choosing not to work with someone is different from cancelling a show. Maybe it's a matter of due diligence'.

Three years before the allegations were made public about Close, the MCA featured his work in a major show called *Prints, Process and Collaboration*. Macgregor tells me she would have pressed ahead with the show if those allegations had been made after it had opened. But would she have created the show in the first place?

'Now, knowing what we do, I would not approach him to exhibit,' she said. 'But despite my support for the #MeToo movement, I don't think we would have cancelled the show. On the grounds that accusations are not enough. If he was convicted, that would be another matter.'

Which brings us to Dennis Nona, one of the most celebrated artists from the Torres Strait—at least until recent times. Nona, a pioneer of linocut printmaking in the north, won Australia's top Indigenous art prize, the Telstra National Aboriginal and Torres Strait Islander Art Award, in 2007. His work is included in collections across the country and around the world, and he was even featured in

the *Australia* exhibition, organised in part by
the National Gallery of Australia and held at
the Royal Academy in London in 2013. Nona
was hung alongside the likes of Tom Roberts,
Arthur Boyd, Sidney Nolan, Fred Williams,
and Indigenous luminaries John Mawurndjul,
Clifford Possum and Rover Thomas.

In early 2015 everything changed. Nona was
sentenced to five years behind bars for raping
a twelve-year-old girl in Canberra two decades
earlier. He had already been serving time for
the rape of her thirteen-year-old sister.

Australian gallery directors responded
by removing his work from display.
Deaccessioning was not on the agenda—
selling his work was seen as a step too
far—but they made a collective decision to
not promote the art in public while the artist

sat in custody. Gerard Vaughan, then director of the National Gallery of Australia (NGA), explained his position to *The Saturday Paper*: 'The NGA, given his recent trial and imprisonment, has judged it appropriate to remove his works from display, and there is currently no plan to return any of these works to public view'.

Sasha Grishin, an art historian and curator, cried censorship in a piece for *The Conversation*: 'Dennis Nona may be a deeply flawed individual and is now being punished for his crimes, but let us not punish ourselves by denying the beauty, importance and profundity of his art'.

In 2017, when Nona was preparing for release, the Council of Australian Art Museum Directors considered his case

again. This group, known as CAAMD, is a leadership forum made up of directors from the ten national, state and territory public art museums. They meet twice a year, and the general purpose is to share and discuss ideas rather than to set specific policies across the sector.

They had already taken the position that if the offending was serious enough to result in a long period of imprisonment, then the artist's work would not be shown while they remained in prison. But what to do when the artist was free? This was the dilemma facing CAAMD when it met in Brisbane in September 2018. Nona, now living back on Badu Island, had twice phoned Chris Saines, the director of the Queensland Art Gallery and the current chair of CAAMD, to make

the case for his art. Community members had also written to CAAMD, saying the council of elders had accepted Nona's apology and the artist had shown remorse.

Saines wrote back on behalf of the other directors: 'Public art museums are increasingly required to respond to the complex and contested links between the effects of serious offending on the reputation of an artist, and on the reputation and responsibilities of the institution that holds or otherwise represents their work.'

While Nona's offending had 'serious effects and consequences', the council also acknowledged his efforts to rehabilitate himself and seek forgiveness. 'CAAMD also appreciates the potential impact on Dennis

Nona's good standing, and the good standing of his work, when major Australian galleries who hold his work elect—for sometimes different reasons—not to include it in collection displays and exhibition programs.'

Saines went on to say each museum would seek further counsel from their boards and relevant staff, including Indigenous advisory groups, before making a final decision. Notwithstanding this, they were open to returning his work to their walls.

Elizabeth Ann Macgregor, another member of CAAMD, told me she hadn't yet made up her mind. Like the others, she was consulting with Indigenous staff: 'Their view,' she said, 'is that showing his work endorses him as a role model in the community and

that his behaviour should not be condoned in this way unless he has genuinely been forgiven by those affected'.

'I think this last point is the critical one,' she said. 'We should expect those that are looked up to and admired—sports stars, artists, etcetera—to set an example. Excusing them because of their 'genius' or skill is not good enough if we are to seriously tackle deep-seated misogyny in society.'

A few weeks after the letter from CAAMD had been sent, I met Saines for coffee in Sydney. The chair of CAAMD is a rotating position, and his term runs until October 2019. As such, he has the challenging task of articulating the position of the Australian art establishment towards artists who offend against community sentiment and the law. As

the boss of Queensland's main gallery, he's also closest geographically to Nona, which may have been also why the artist chose to phone him.

'We felt that, if he was imprisoned, why should his work be out in the world furthering the development and advancement of his good reputation?' Saines said. 'If a particularly strong criminal sanction has been placed on an artist for unlawful conduct, then it seems invidious to me that we would continue to present their work in a publicly funded institution where it could be seen by victims' relatives and others. You need to be sensitive to the fact that there is a broad section of the community who would be deeply offended by the presence of the work given the seriousness of the punishment meted out to Dennis.'

The more you look into the issue, Saines said, the more irreconcilable contradictions emerge. For this reason, he said it was important to communicate a consistent, rational explanation for any decision. 'It's easy to be accused of moral panic or ethical fundamentalism, but in the end public institutions have to reflect the values of the communities that they serve. To be completely tone deaf to those concerns is an abdication of that central responsibility.'

Along with his interstate counterparts, Saines has given this subject a lot of thought. 'Life is messy', he said. But he's sure of one thing: Dennis Nona is a major artist, one of the best of his generation from the Torres Strait, and his legacy is both 'secure and serious'.

'I know that his conduct has jeopardised for a period of time his standing in the

community. Everyone is making a decision around this either by self-censoring, electing not to proceed, or taking time to decide when the time is right to proceed with greater levels of engagement with Dennis and his work.'

Nona will return to gallery walls soon enough. In the next year or so, if you find yourself wandering through the Queensland Art Gallery, or any number of public museums across Australia, there's a good chance you might find yourself face to face with a print by a Torres Strait artist with a familiar name. 'I do think that these things ultimately get reconciled through the passage of time', Saines said.

This book is all about great art by flawed artists, so we were going to make it to Woody

Allen eventually. On the one hand, he's a pro-
lific director, actor and screenwriter whose
career spans half a century. You can list his
awards—four Oscars, including two in 1978
for *Annie Hall*—but that doesn't come close
to describing the immense cultural footprint
of this most idiosyncratic talent.

But on the other hand, there's Woody
Allen the man. In 1992 he gave a now famous
interview to *Time* magazine about his rela-
tionship with Soon-Yi Previn, the adopted
daughter of his former partner Mia Farrow.
'The heart wants what it wants', he said. The
interview also had exchanges like this:

> Q. Do you use your movies to work through
> dilemmas you're facing in life?
> A. No, people always confuse my movies
> and my life.

Q. But don't you confuse your movies and your life?

A. No. Movies are fiction. The plots of my movies don't have any relationship to my life.

Like Roman Polanski, the claims against Allen are well documented. Allen has been accused of sexually abusing his adopted daughter, Dylan Farrow, when she was seven. Farrow addressed the issue in an open letter in 2014, shortly after he had been nominated for another Academy Award (for *Blue Jasmine*, for which Cate Blanchett won best actress). She appealed to some of the actors who have worked with Allen, as well as the audiences who watch his work. 'For so long, Woody Allen's acceptance silenced me. It felt like a personal rebuke, like the awards and accolades were a way to tell me to shut up and go away.'

Allen denies her account, but his reputation has taken a hit from the renewed attention as part of the #MeToo debate. High-profile actors, among them Colin Firth, Greta Gerwig and Rebecca Hall, distanced themselves from his work.

Even critics are weighing up how to respond. AO Scott, *The New York Times* film critic, wrote an anguished piece in January 2018 saying he was reassessing his relationship with Allen's films, a body of work that was 'saturated with his personality, his preoccupations, his biography and his tastes'. Scott said Woody Allen films were part of the 'common artistic record', having informed the memories and experiences of many viewers. But now he knew more about the man, he wanted to consider anew the value of the work.

After all this time, the life was becoming inseparable from the art: 'Part of the job of a critic—meaning anyone with a serious interest in movies, professional or otherwise—is judgement, and no judgement is ever without a moral dimension'.

<center>***</center>

Robert Sylvester Kelly, an R&B singer better known as R Kelly, once spent four weeks at the top of the Billboard Hot 100 with a song called 'Bump N' Grind'. The song opened with these words:

> My mind's tellin' me no, but my body, my
> body's tellin' me yes
> Baby, I don't wanna hurt nobody
> But there is something that I must confess
> to you.

This music is packed with suggestive lyrics and swagger—that's part of its appeal—but the lyrics resonate in new ways when it comes to R Kelly. He has sold millions of albums since his 1993 debut *12 Play* (more than 'foreplay', you see). He has also denied repeated accusations of sexual abuse of underage women, among other nefarious acts.

In 2017 a campaign was launched to 'mute' R Kelly: cancel his concerts, banish his music and encourage anyone who profits from his music to cut ties. Then Spotify announced a new policy that seemed like a logical extension of that campaign. In addition to removing 'hate content', the streaming service would target content made by artists 'who have demonstrated hateful conduct personally'. Citing R Kelly and XXXTentacion, a rapper

charged with assaulting a pregnant woman (and later shot dead in Florida), Spotify wanted its editorial decisions to reflect the values of the company.

These artists would still be available to stream but Spotify would no longer promote them on their popular playlists. It was a rare attempt to formalise creative sanctions against artists behaving badly.

The company faced a backlash from music industry figures who pointed to numerous artists who could fall under the guidelines, from David Bowie and Eminem to Sid Vicious and Miles Davis. Spotify then backed away from having a policy tied to the behaviour of artists. 'We don't aim to play judge and jury', it said.

Kelly later released 'I Admit', a 19-minute autobiographical song in which he addresses

all these issues, including the journalist who has pursued him for years. He admits he had 'made some mistakes'—trusting people too much, being tempted by drugs, talking dirty, sleeping with his girlfriend's best friend and so on—but asks to be left alone to make music and 'age gracefully'. It's beyond strange to hear a singer asking his accusers to define what they mean by 'cult', or 'sex slave'.

> Yeah, go ahead and stone me
> Point your finger at me
> Turn the world against me
> But only God can mute me.

Can anything good come from silence? There's no more potent case than Richard Wagner and Israel, where there's been an

informal but very real policy of silence for the past eight decades. It's a deeply complicated issue, full of symbolism, half-truths, long memories and deep wounds. Woody Allen even makes a passing reference to it in his 1993 film *Manhattan Murder Mystery*: 'I can't listen to that much Wagner, you know. I start to get the urge to conquer Poland'.

As a composer, Wagner stands among the giants. He made a monumental contribution to music with operas like *Der Ring des Nibelungen*, *Tannhauser* and *Parsifal*, a body of work that sounds to many of his admirers like the peak of human creativity. But his reputation is tempered by his strident anti-Semitism as well as his connection, however tenuous, to Nazism. Wagner might have worked with many Jewish musicians but he

is also judged by his own words: in his essay *'Das Judenthum in Der Musik'*, or 'Judaism in Music', he writes about his 'involuntary repellence' towards Jewish people.

Wagner died in 1883, six years before the birth of Adolf Hitler, but there was something about that grandiose nationalism and Norse mythology that struck a chord with German leaders in the first half of the twentieth century. Hitler befriended Wagner's family and regularly attended performances of his music. Wagner soon became a symbol of German exceptionalism and the Third Reich. The music of 'Hitler's favourite composer' was later rumoured, without evidence, to have been played in concentration camps during the war.

In Israel, the Wagner boycott can be traced to *Kristallnacht* in 1938. When word spread

about the anti-Jewish pogrom in Germany, the Palestine Symphony Orchestra removed from a concert program the prelude to *Die Meistersinger von Nurnberg*, a Wagner opera. From this point his music all but disappeared from public performance in Israel, and opposition to his work became more entrenched. There have only been sporadic attempts since then to play Wagner in Israel—most famously in 2001, when the Jewish conductor Daniel Barenboim led the Berlin Staatskapelle orchestra in a surprise encore performance of Wagner, a move described by Jerusalem's mayor as 'arrogant, uncivilised and insensitive'. Even the orchestra was split: during rehearsals the cor anglais player hit a wrong note to protest Barenboim's plans. After the concert the ban remained in place. Some

observers believe it may have even hardened the resistance.

Wagner is far from the only composer with an unpalatable past. Richard Strauss was president of the Führer's *Reichsmusikkammer*, and his music was banned from Israel for many years. Violinist Jascha Heifetz was assaulted in 1953 for playing Strauss in Israel—but the country moved on, and Strauss is now performed without incident.

To learn more about this battle of symbols, I decided to visit the Holy Land itself. My guide of sorts would be Asher Fisch, the principal conductor of the West Australian Symphony Orchestra. Fisch began his career alongside Barenboim and has since conducted some of the world's most prestigious orchestras. He's particularly well regarded

for his knowledge of Wagner: as well as the Ring Cycle in Adelaide in 2004, he has performed Wagner all over the world, from Vienna and Dresden to Naples, Seattle and New York. The reason I wanted to talk to him was that he once tried, without success, to play Wagner in Israel, too.

We met on a warm day in Rabin Square, in the centre of Tel Aviv. Fisch, born in Jerusalem, lives most of the year in Munich, but he was in Israel to celebrate his sixtieth birthday with friends. We walked to a nearby French bistro, where he alternated between Hebrew and English while organising a table, negotiating the menu and talking to me about Wagner. 'It's fascinating,' he said. 'American Jews let it happen. If they choose not to go they don't go, but they don't

protest or demonstrate. It's a totally Israeli phenomenon that people protest if you try to perform Wagner.'

Fisch grew up in a German enclave of Jerusalem, the son of two German Jews who escaped the war. He started conducting in his early twenties and joined Barenboim in Berlin in 1992, which is when he discovered what had been missing from his life. Apart from a single recording of *Tannhauser*, and an education curriculum that barely mentioned the composer, he had spent the first three decades of his life in the dark about Wagner. Fisch can still recall every detail from when Barenboim first asked him to prepare the orchestra for *Parsifal*, including the moment he lost himself in the music and missed his cue.

'It was instant,' he told me. 'It was more than love. It was really a life-changing experience.' Not long after this Fisch conducted *Parsifal* for the first time, and his response to the music was so intense that he went home shaking, with a fever. 'I don't know what comes first, if it's the harmonies or the melodies or the sound. I think it's the sound. It's very visceral. It's a physical thing. When you conduct Wagner, you're drawn to the music. You can never stay outside. You're in the sound.'

In 1997 Fisch conducted *Parsifal* at the Staatsoper in Vienna. It was a momentous occasion to perform Wagner in the music hall that had purged Jews from its ensemble six decades earlier. Even more moving was the presence of his mother, Judit. Born in

Germany, she had made her way to Jerusalem from Vienna in 1941, and she was the only one from her family to survive the war. 'For her,' Fisch says, 'it was emotional closure'.

It was emotional for Fisch, too: 'Look, a Jewish kid from Israel at the Staatsoper, at the conductor's podium where Mahler started his career, to conduct *Parsifal*, the most Christian of all Wagner operas. It gives you a feeling of fulfilment and achievement'.

Fisch's late mother weighs on his mind as he considers Wagner in Israel. While he takes issue with the caricaturisation of Wagner as an anti-Semite, he is certain the composer would not be an issue today if he had he not been adopted by Hitler. To reclaim the music is to prevail over the Nazification of Wagner.

This is why, in 2012, Fisch organised a performance in Tel Aviv featuring Israeli musicians playing Wagner. Mindful of the Barenboim experience, he was careful to use only private money, not government funds. And to cultivate an open, intellectual atmosphere, it was billed as a day of lectures and discussions that culminated in a concert. Barenboim had taken his audience by surprise, so Fisch organised a respectful, open atmosphere where everyone knew what was coming. But as the time approached, venue after venue pulled out, and he was forced to cancel altogether.

More than five years have now passed, and Fisch is pessimistic about the direction his country has taken. He's no longer pushing for the ban to be overturned and doubts it will happen any time soon. He spent ten

years in charge of the Israeli Opera but now his focus is elsewhere. 'I was always dreaming and hoping. But I was involved in the musical life here, and now I'm not. So I cared, and now I don't.'

Fisch is an erudite, charming lunch companion, and it's hard not to share his enthusiasm for music after an hour in his presence. His affection for Wagner has few limits: 'I would put him on the highest level of genius in music history.'

I wondered, though, whether there was any part of Wagner's music that made him uncomfortable. Considering, you know, what came next.

There is indeed one part he finds difficult. A few lines in *Parsifal*, near the end of the first act, sung by the knights of the grail:

froh im Verein,
brudergetreu
zu kämpfen mit seligem Mute!

[Rejoicing in the unity
of brotherly faith,
let us fight with holy courage!']

'It's the word *kämpfen* [fight] which gets to me', Fisch said. 'It always sounded very Nazi to me. I remember the chorus in the State Opera in Berlin, this was their music, they were really going for it. You could hear bad aspects in German history through the men singing. They almost sound drunk and very

aggressive. This was the only line that ever bothered me in the whole of Wagner.'

After lunch with Fisch, I took a bus from Tel Aviv to Jerusalem. I had come to see Dan Meridor, a former deputy prime minister who was both a Wagner enthusiast and a realist about public performances of his music in Israel. Meridor welcomed me to his home in Rehavia, an upmarket suburb where he had known Fisch as a boy. He mentioned some of the Australian politicians he had encountered over his career, then settled in to talk about his love of Wagner, who he listens to often at home.

'It is something symbolic in this country, an unwritten rule that Wagner is not played', he

said. 'For how many years, I do not know. We want to keep the memory of what happened.'

When he was a boy, and still living in the same apartment block, Meridor was given a toy ship by a relative. The toy was made in Germany, so his father made him throw it into the bin. 'I remember this very vividly', Meridor said. 'He said this exactly: "This was not a war. They exterminated our people."'

Meridor lives with several tensions. He loves Wagner but doesn't oppose the ban on performance in Israel. He speaks German and loves German culture but refuses to visit the country, even if that meant turning down his prime minister. He's been to Austria, Poland and several other European countries, but never to Germany. His family

can go where they like, but he won't budge: 'I decided to keep some memory'.

'I was born two years after the end of the massacre in Europe,' he said. 'And I can tell you, without being too dramatic, that my life is full with that. Almost every day of my life I think of it. The perspective of my life, what we do here, what we should do here, what is good, what is bad, is always laden to this memory of what happened in Europe to my people.' He falls silent. 'Cultural memory is important. I didn't decide that Wagner would be the one, but there is a logic to it.'

Meridor is friends with Barenboim, and he was there that day in 2001 when the conductor announced he was going to play Wagner in Jerusalem. A senior politician at the time, Meridor was among the small number of

audience members who walked out. 'To come like he did and try to break it, and force it upon the Israeli public, I think it was wrong.'

No official declaration can end the ban, Meridor said, since no official declaration began it. How long will it take for this to change? Once the last Holocaust survivors have passed, perhaps? Meridor thinks for a moment, then mentions the expulsion of Jews from Spain in 1492, after which many Jews boycotted the country for five centuries.

'I'm not saying it will be 500 years, or 80, I don't know', he said. 'I'm not judgemental but still there should be a public discourse and decision to change, and as long as there is not, I think there is something important in keeping a memory of such a sensitive historic and moral issue like the Holocaust.'

The next day I made my way to the airport, listening to *Parsifal* on headphones, seeking out the part that gives Asher Fisch the chills. At immigration I explained the nature of my trip and the officer responded while leafing through my passport: 'You're not going to find much Wagner here.'

Since we're talking about Nazis, we can't go past Leni Riefenstahl, the German dancer turned actress, filmmaker, propagandist and photographer, who died in 2003 at the age of 101. Unlike Wagner, Riefenstahl was very much a contemporary of the Nazis. And unlike Wagner her work is unlikely to ever be released from their grip. Her best-known films—*Triumph of the Will*, which

chronicles a 1934 Nazi rally in Nuremberg, and *Olympia*, a two-part film about the 1936 Berlin Olympics—are considered both technical triumphs and paeans to a particular kind of German exceptionalism.

Riefenstahl tried to distance herself from Hitler later in life, but the pair were close in the lead up to the war. In 1937 she told *The Detroit News*: 'To me, Hitler is the greatest man who ever lived.'

In 1975, after Riefenstahl had released a book of photography from southern Sudan, the American writer and political activist Susan Sontag wrote a piece for *The New York Review of Books* called 'Fascinating Fascism'. Sontag was concerned about the rehabilitation of Riefenstahl's reputation—her 'current de-Nazification and vindication as indomitable

priestess of the beautiful'—when her creative output, both during the Third Reich and later, 'consistently illustrated some of the themes of fascist aesthetics'. A decade earlier Sontag had made the case for the 'sublime neutrality' of art, but here she was unwilling to separate the artist from her past.

'The force of her work is precisely in the continuity of its political and aesthetic ideas', Sontag wrote. 'What is interesting is that this was once seen so much more clearly than it seems to be now.'

It's true what Asher Fisch said about American Jews choosing not to protest against Wagner. In New York I visited Peter Gelb, general manager of the Metropolitan Opera,

to ask about the separation of the artist and the art. (The 'Met' has faced these questions before. Back in 1994, before Gelb was boss, the company parted ways with a fiery soprano named Kathleen Battle, saying her 'unprofessional actions' during rehearsals had been 'profoundly detrimental to the artistic collaboration among all the cast members'. She returned to sing for the company in 2016.)

Wagner is a regular feature on the stages of the Met, but so far Gelb has not heard any complaints about his presence. 'There was much more disquiet when I put on *The Death of Klinghoffer*', he told me. That was in 2014; a John Adams opera was branded in some quarters as anti-Semitic. 'In fact, in this very office, I had five rabbis telling me I had to cancel the production. I tried to explain

to them that I was brought up as a Jew to be curious about art, and also that they were way off base. I said I believed in intellectual curiosity as a Jew and I thought they were exhibiting the opposite by trying to shut us down and they got so furious at me they just got up in a huff and walked out.'

The Met sends productions of its operas to various cinemas around the world, including Israel—unless the opera is by Wagner, in which case Israel is left out.

Gelb has long been aware of the sensitivities surrounding Wagner—'Of course! I'm a Jew'—but he credits his New York upbringing for exposing him to a variety of cultures. He knew about the anti-Semitic tendencies of many writers, Ernest Hemingway included.

But he was also brought up to be inquisitive, and to resist any hints of censorship.

'It was possible for me and for many people to separate the art from the artist', he says. 'That doesn't mean it's automatic. It's easier when it's a great artist. So when I was thirteen years old, and I read *The Sun Also Rises*, I recognised that Hemingway was being anti-Semitic in making the lout in the story a Jew, but it didn't threaten me as a Jew.'

A few months before my chat with Gelb, the company had fired its chief conductor James Levine over claims of sexual abuse. Levine denied the allegations and sued for breach of contract and defamation. The news shocked the classical music world, since Levine had come to define the Met over four

decades and was widely regarded as one of the world's greatest living conductors.

In October 2018 the Met presented a new opera in New York. It was called *Marnie*. The opera, which had its world premiere the year before in London, was based on Winston Graham's 1961 book, the same novel that had inspired Hitchcock's film.

In the audience on opening night was Tippi Hedren, wearing red, the colour that so utterly unnerves her character on screen.

One night, like so many others around the world, I turned on Netflix to watch Hannah Gadsby's remarkable farewell to comedy,

Nanette. The Australian comedian tells a revealing story about struggling against a paternalistic, homophobic world, and selling herself short within the constraints of comedy.

Gadsby also takes aim at the art world in general and Picasso in particular. She's unforgiving when talking about the way he took advantage of an underage girl. 'Does it matter? Yeah. It actually does. It does matter.'

Thousands of words have been written about the behaviour of artists, but Gadsby really cuts through. It's hard to watch *Nanette* without feeling uncomfortable about Picasso and other artists, especially since Gadsby puts them in the context of a broader pattern of behaviour that has left so many people voiceless and powerless over such a long period of time.

She also made me consider the baggage that I bring to this debate. As a straight, white man it's not my place to tell others how offended or uncomfortable they should feel. Clearly other perspectives need to be taken into account, including the price that might have been paid in the pursuit of creativity.

After all this time, though, I still find it hard to resolve my own thoughts into a neat, unequivocal conclusion. We can't ignore the artist, but that doesn't mean we have to forgive them either. Whether it's Caravaggio or Wagner, Woody Allen or Dennis Nona, we need a more complex engagement with culture, but an engagement all the same.

Whether we're prepared to overlook the behaviour of an artist in order to enjoy their art has a lot to do with individual perspective.

This is not to say that cultural value cannot be measured objectively. But it matters what we bring to the art and what we take from it, too. I'm thinking of one night in Osaka, in 2014, watching a solo performance by the American pianist Keith Jarrett. I've been a fan of his music for years, and this wasn't the first time I had travelled overseas to see him play. He improvises entire concerts of music, reaching within himself to scale some of the most sublime, transformative heights imaginable. His recordings are breathtaking, even more so if you're lucky enough to be there during the moment of creation itself.

The stakes are always high. He's utterly exposed, concentrating intensely, hostage to whatever mysterious source he draws on for this music. For this reason, he sometimes

takes issue with audiences or promoters if the conditions aren't just right.

This is what happened that night in Osaka. The room had a loud echo and too many people were coughing. I knew those little percussive bursts from the audience would be causing anxiety on stage; they were distracting me, too. Before long Jarrett was arguing with the audience. He walked off then returned to argue with a heckler: 'Find me a genius who isn't distracted. You won't. I'm only human.' It was awkward and tense. After the show an angry crowd gathered outside the box office, demanding answers.

Those outbursts don't put Jarrett in the same league as the other artists mentioned in this book. Clearly not. But my point is this: by

the end of that night, I didn't much like the man. His music, though, was another matter.

Three nights later I was back to see him again, this time in Tokyo. The crowd was quiet, and the concert passed without incident. It was a beautiful performance, but in the audience it wasn't comfortable for a moment. I sat unmoving in my seat, barely daring to breathe, resenting the role of the pianist in the stress we were all feeling, still annoyed about his concert from the other night and nervous about whether he would explode again, but knowing there was nowhere I would rather be at that moment than in a room full of strangers, watching this man and this music come to life.

Acknowledgements

I'm grateful for the assistance and wisdom of numerous people around the world. In the United States, Peter Gelb, Glenn Lowry, Tim McKeough and Sara Beth Walsh; in Israel, Yehezkel Beinisch, Asher Fisch, Dorit Hersovici and Dan Meridor; and in Australia, Christopher Allen, Elizabeth Ann Macgregor, Dave Mullins, Nicolas Rothwell, Chris Saines, Karen Tinman and Matthew Westwood. Thanks as always to Margaret Connolly, and to Louise Adler, Sally Heath and the MUP family. As well as the sources acknowledged in these pages, I owe a particular debt to a book that Fisch urged me to read: Na'ama Sheffi's

The Ring of Myths: The Israelis, Wagner and the Nazis (translated by Martha Grenzeback and Miriam Talisman, Sussex Academic Press, 2013.) Above all my deepest gratitude to Zoe, and to our boy, Raphael.

hachette
AUSTRALIA

If you would like to find out more about
Hachette Australia, our authors, upcoming events
and new releases you can visit our website
or our social media channels:

hachette.com.au

 HachetteAustralia

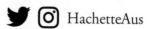 HachetteAus